A Glasses Menagerie

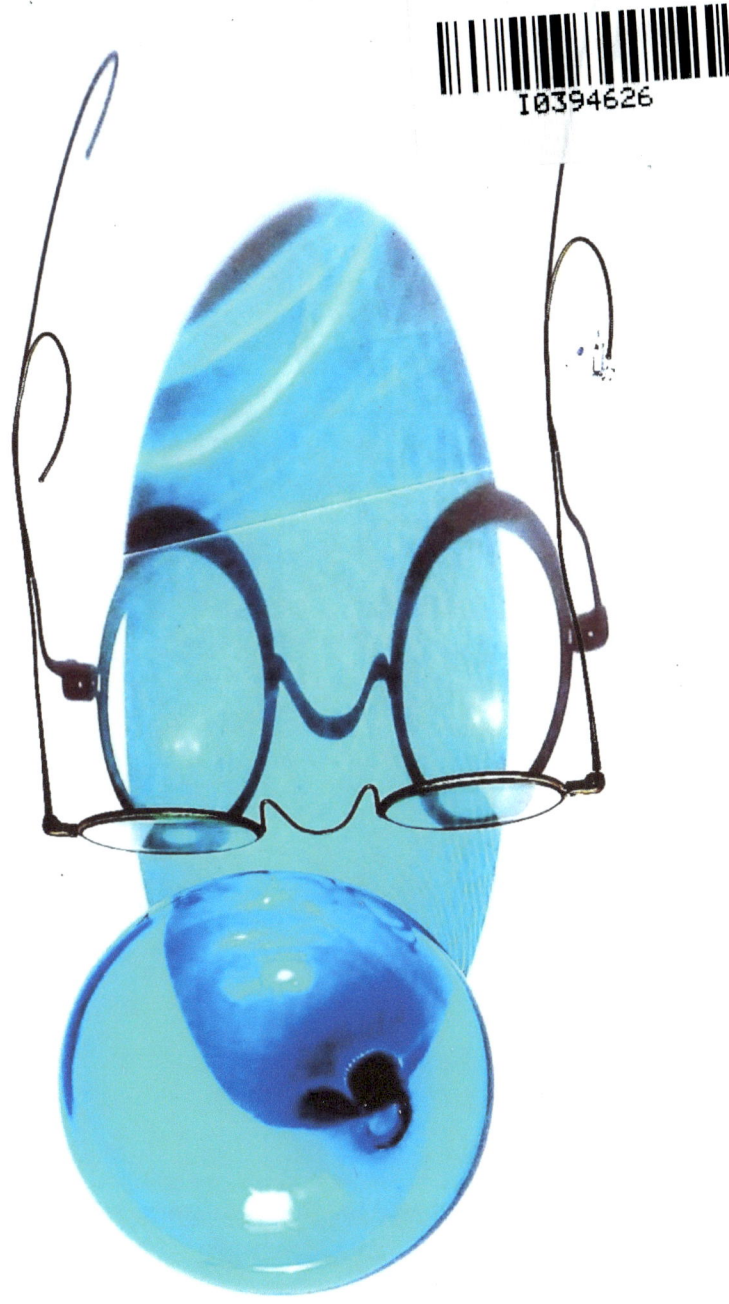

By: E R Hart

erhartj@sbcglobal.net

A Glasses Menagerie

Glasses are glasses, some would say, but really they are a far more varied bunch than first meets the eye. To begin, there are water glasses and eyeglasses, there are crystal glasses and sun glasses, plain Jane glasses and champagne glasses, pince-nez and frappe, hourglasses and whiskey sour glasses: there are tankards and tumblers, the goblet, the flute; there are clip-ons the spyglass, and the monocle to boot. Also Brandy snifters, the chalice, bifocals and reading, in every size, shape and color you might want or be needing.

And of course there are looking glasses.

And they all have shadows, not just in black and white, but in every color of the rainbow. You will find many of them gathered here, a mini-menagerie of Glasses, along with a few close friends.

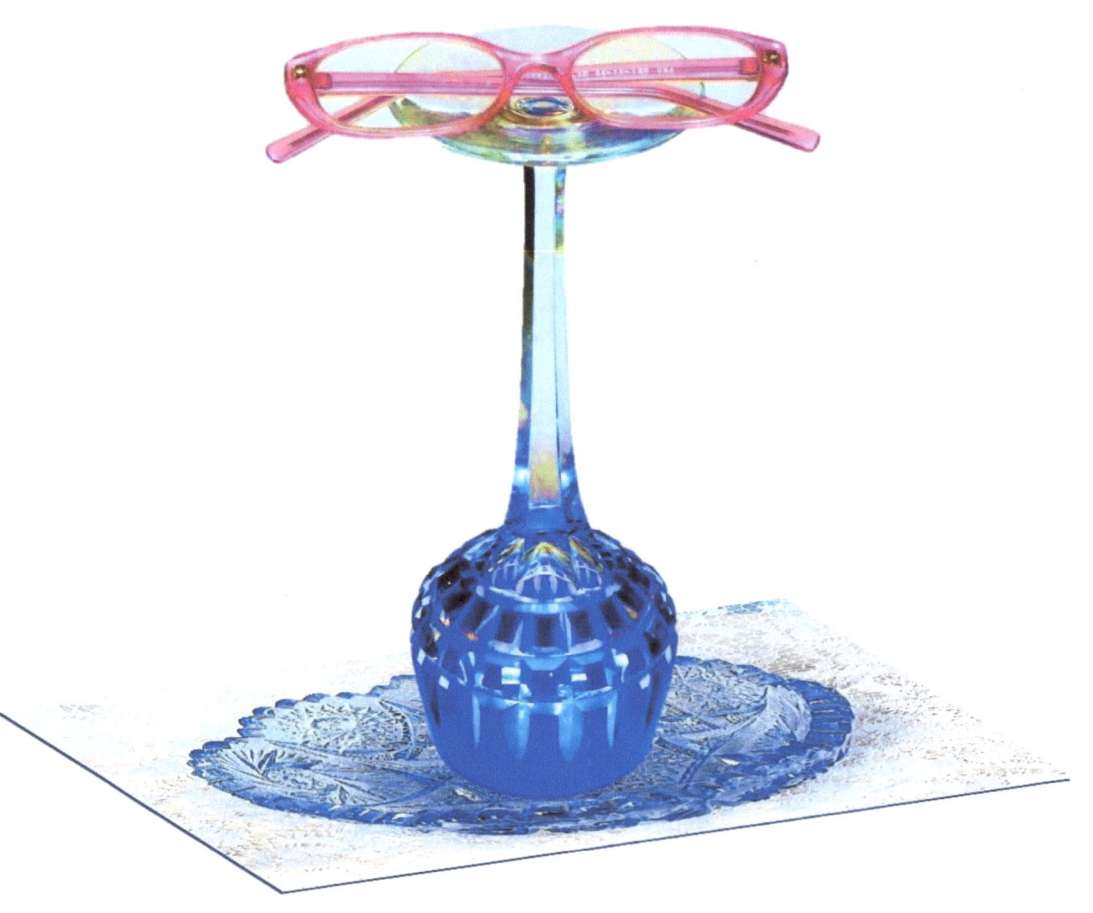

Glasses

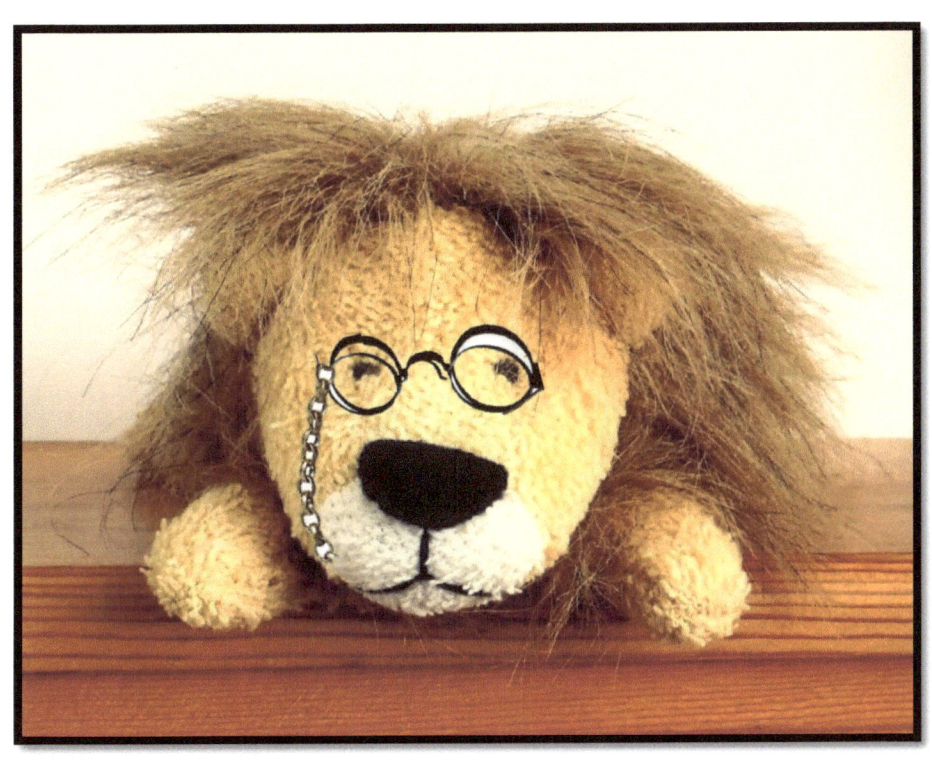

Leo the Pince-nez lion.

A Short Story

Hello there!

--so nice to see you again.

------and I love you too!

What would you like for breakfast?

The End

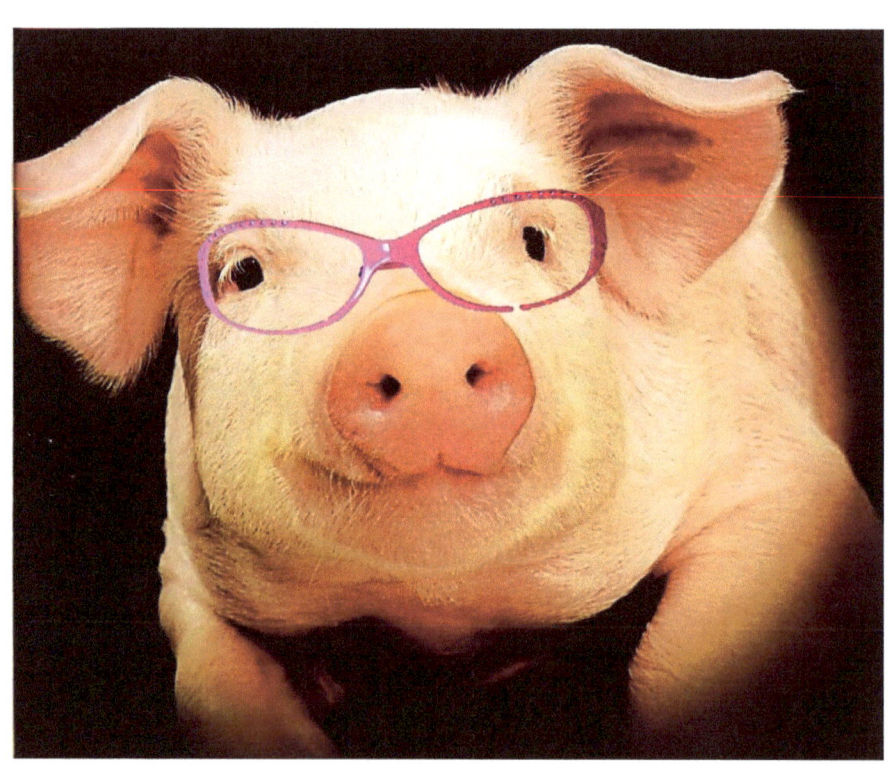

Pink pig in pink glasses.

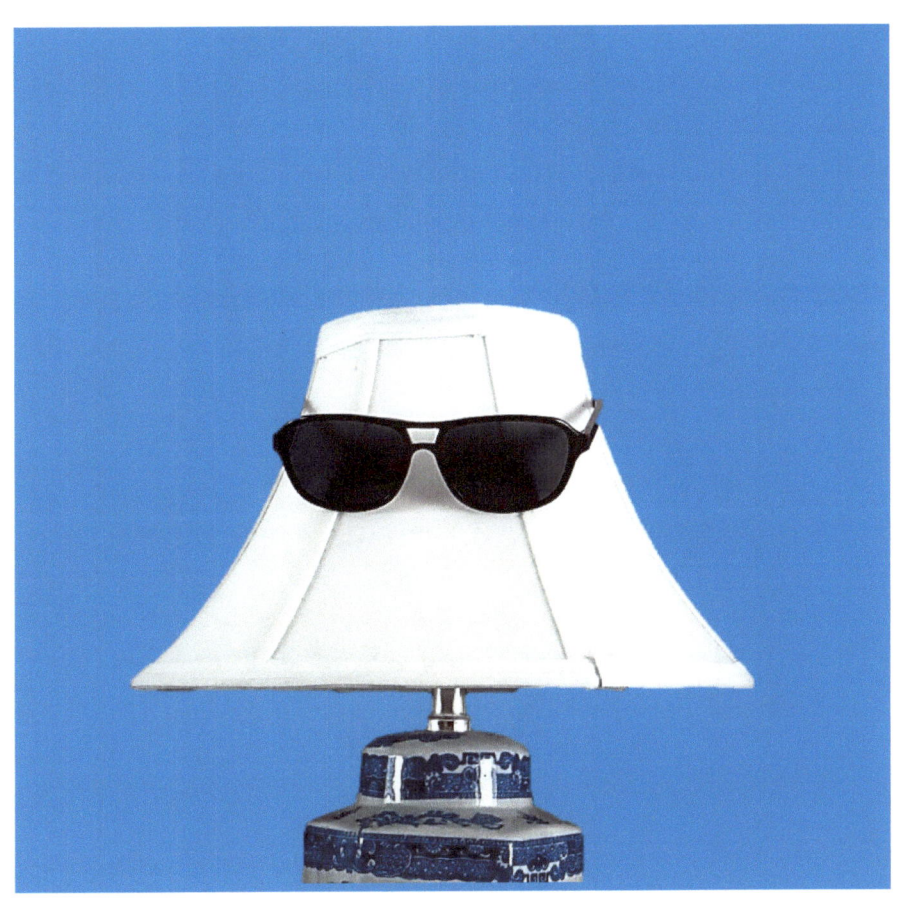

Shades

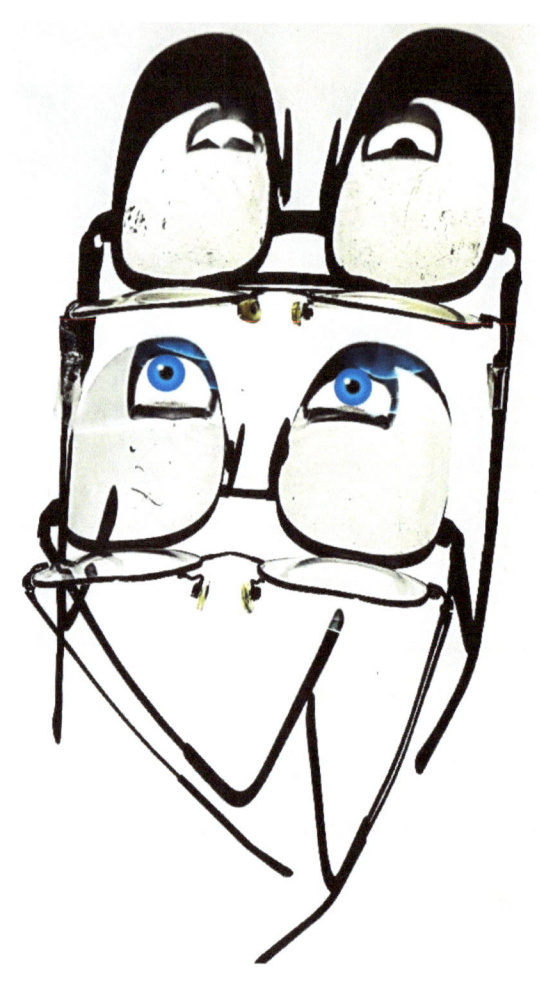

No way! They've got to be contacts!

A Tale of
Two Spectacles.

Simple Elegance --

leads the way!

Age before Elegance, any day!

Says Who??

The End

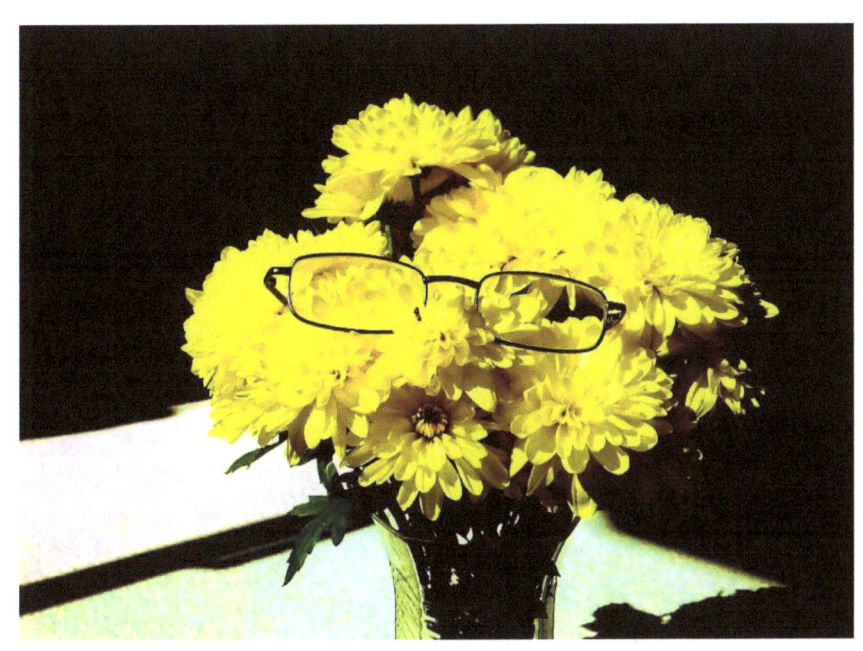

Ocularus Chrysanthemumus.

"Don't make a spectacle of yourself!"

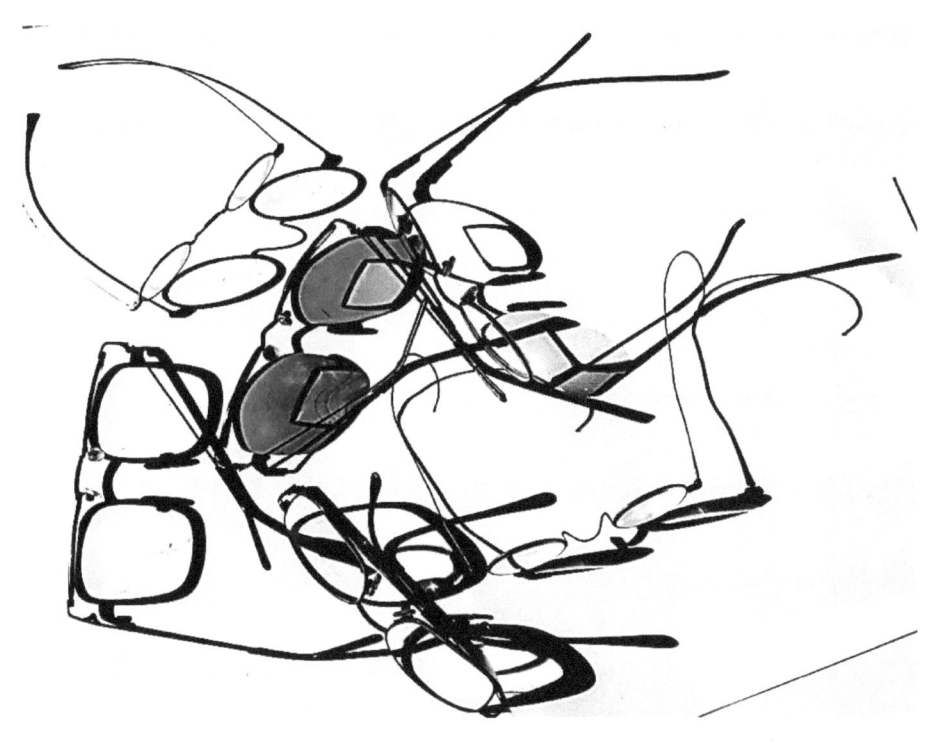

Hodge-podge

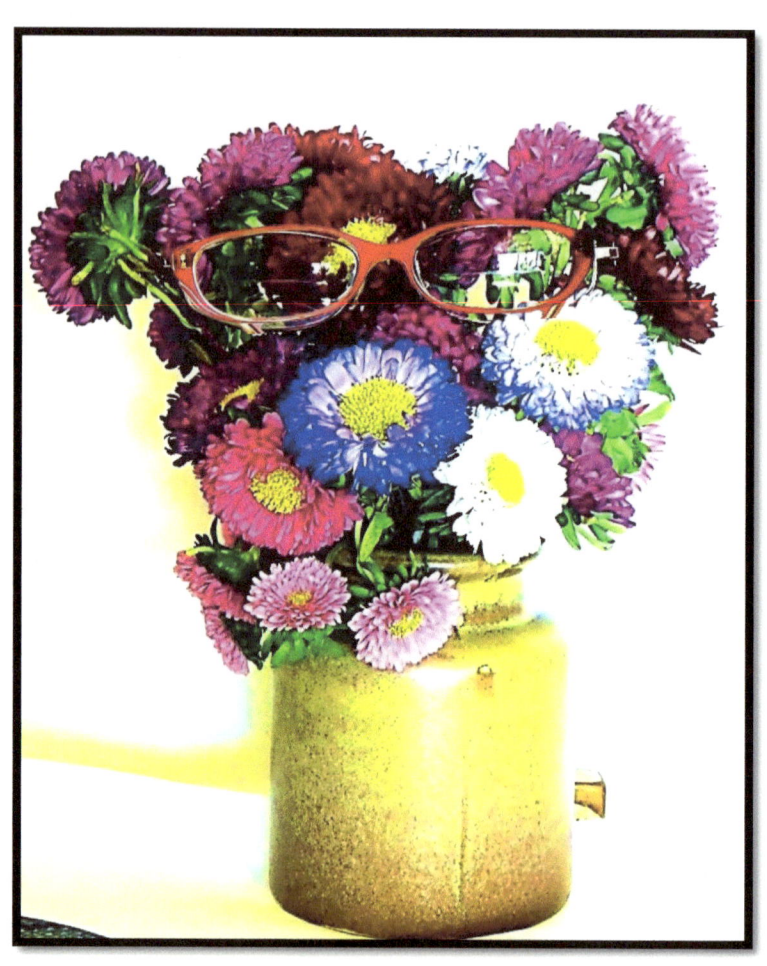

Forever Aster

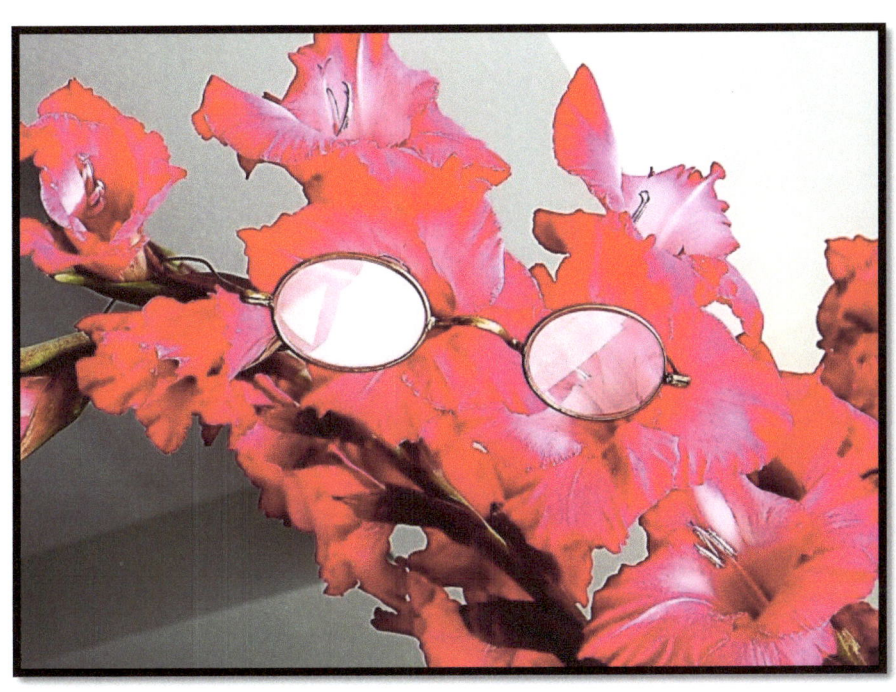

Glad to see you ---

			March 2017			
SUN	MON	TUE	WED	THU	FRI	SAT
			1	2	3	4
5	6	7	8	9	10	11
12	13	14	15	16	17	18
19	20	21	22	23	24	25
26	27	28	29	30	31	

Beware the Eyes of March!

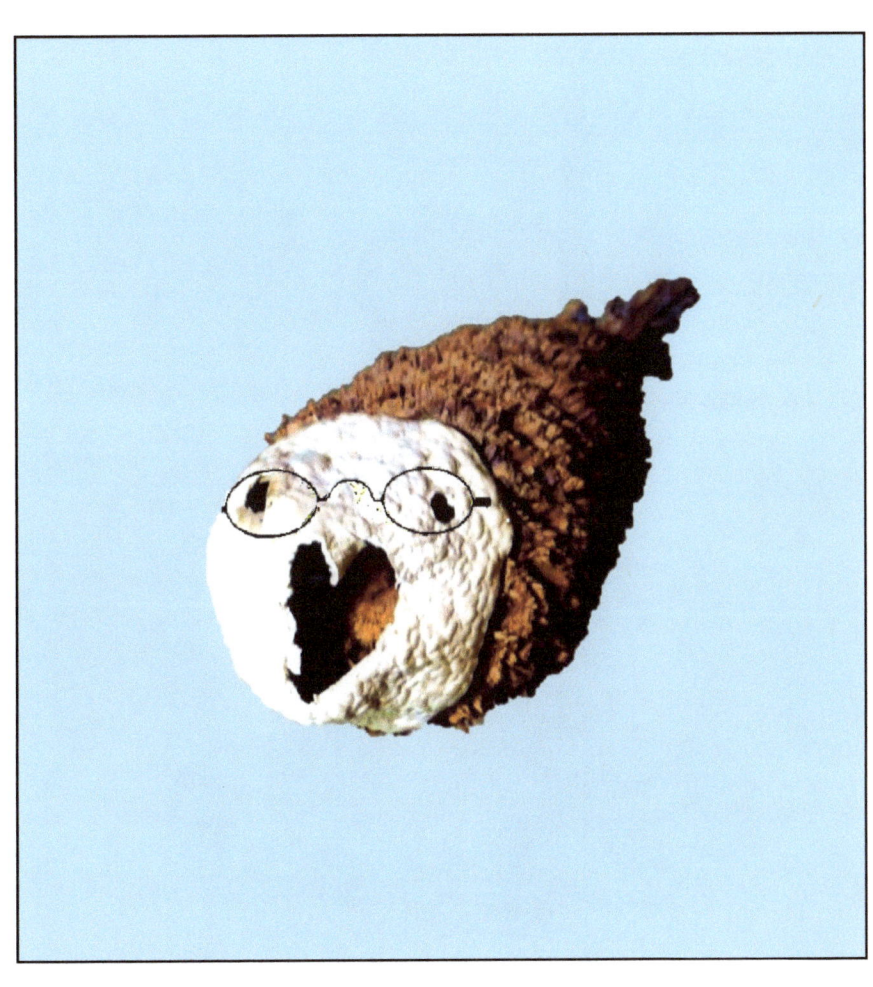

Neither fish nor fowl – (nor pine cone, really)

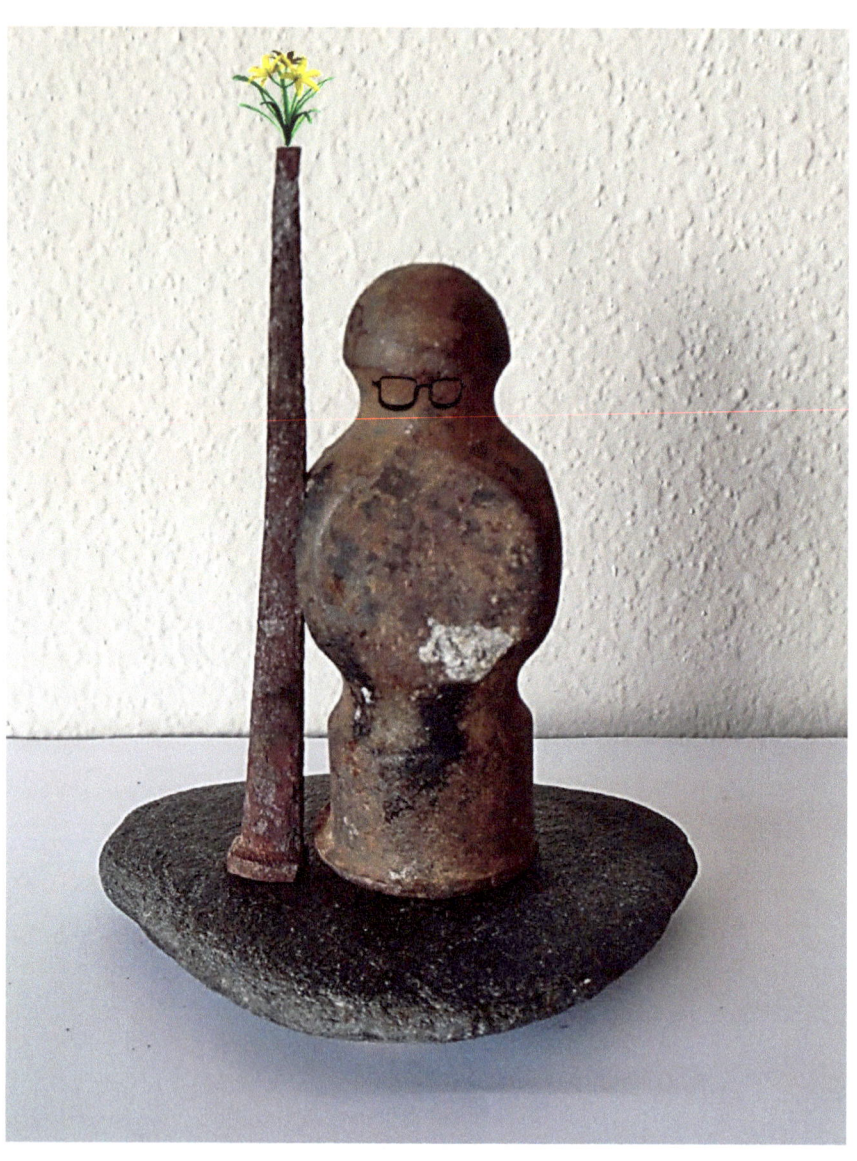

Who will watch the watchman?

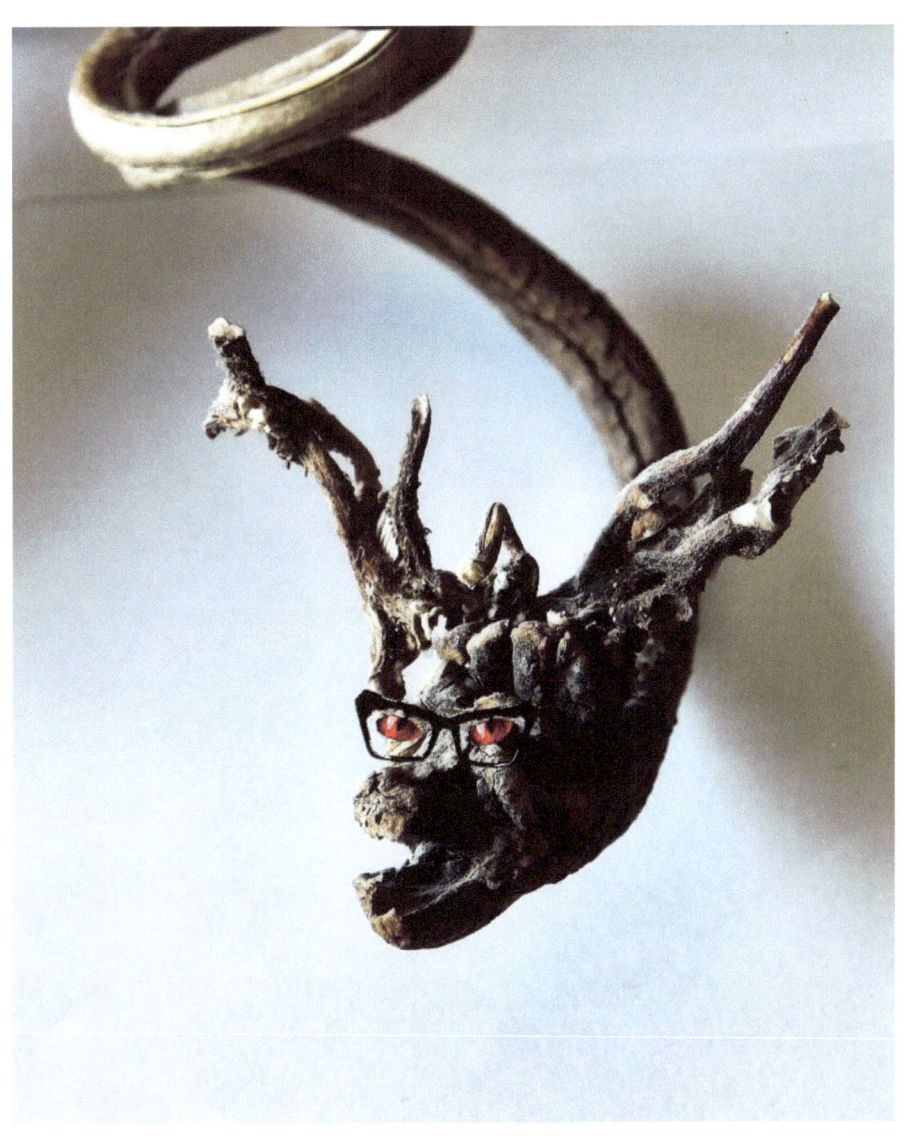

Glassy-eyed Dragon

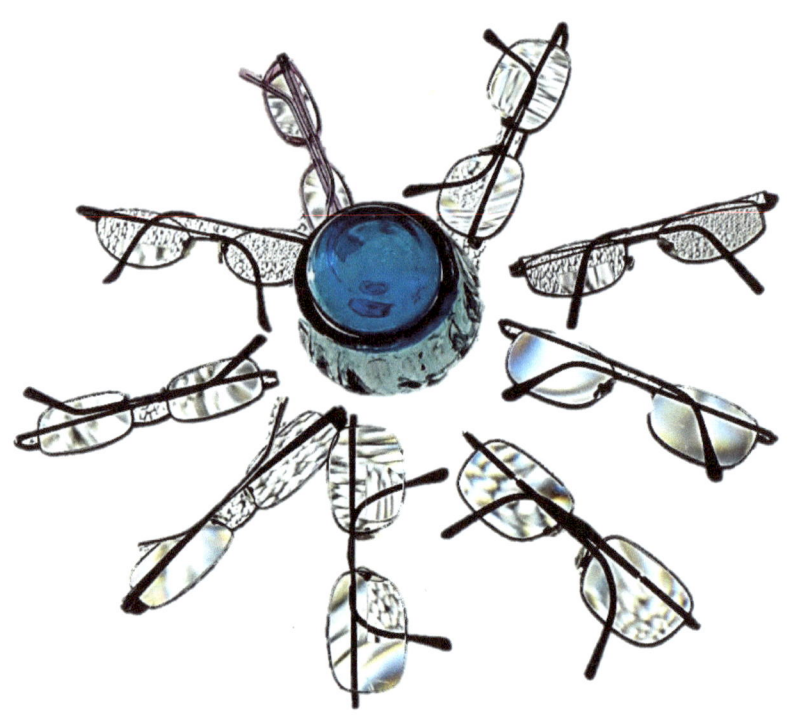

Circle the Glasses!

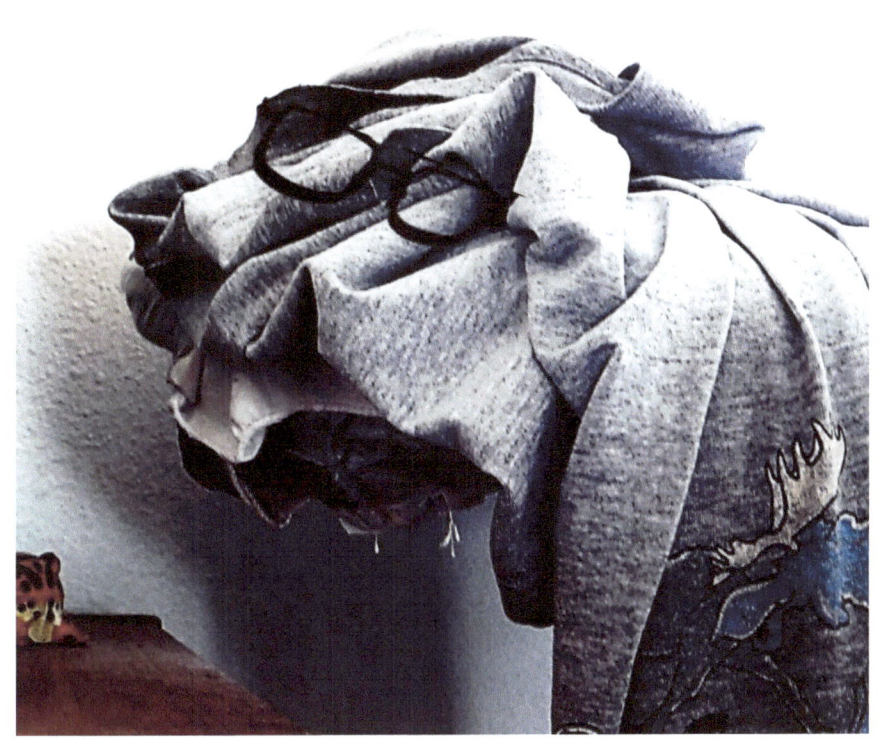

Woof, or Grrrr?

A fine Spectacle!

Four eyes are better than two.

A Gaggle of Glasses.

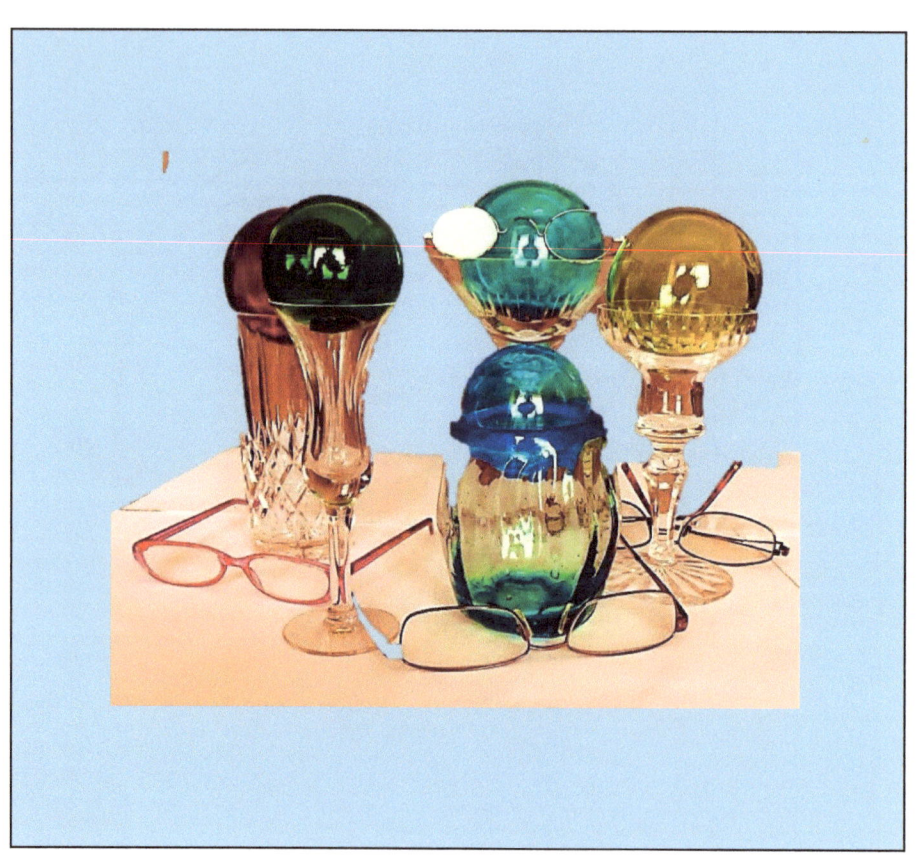

Glasses and Glasses

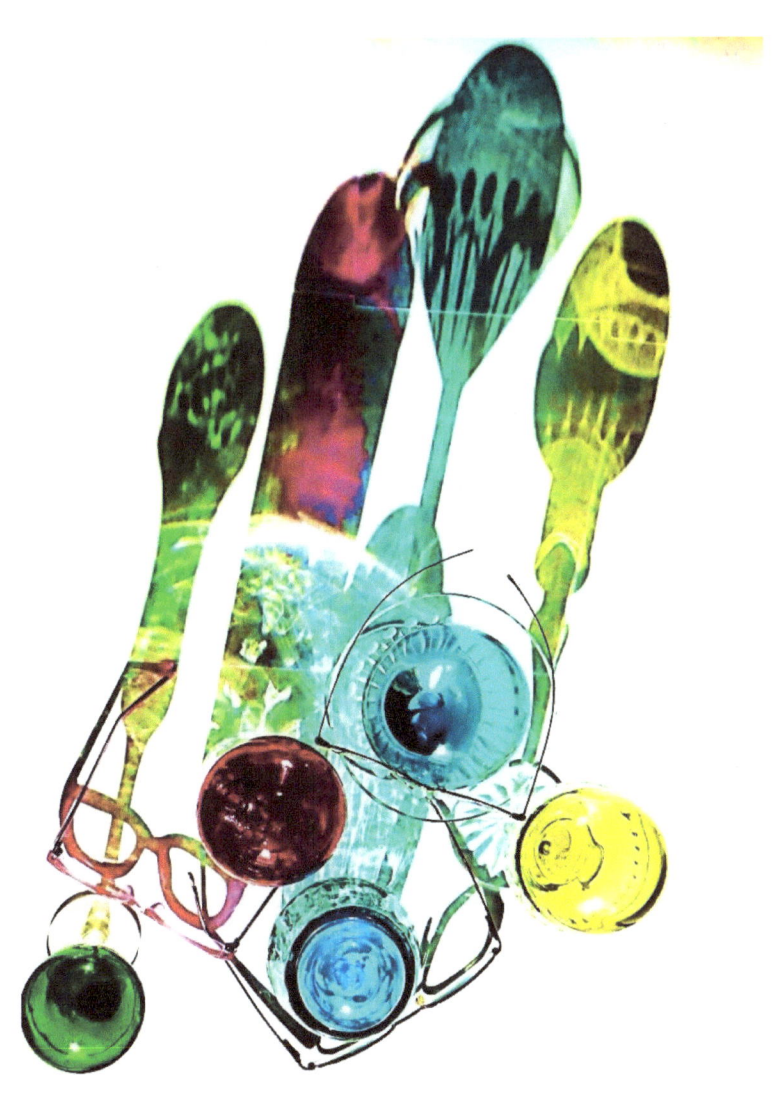

Glasses and Shadows

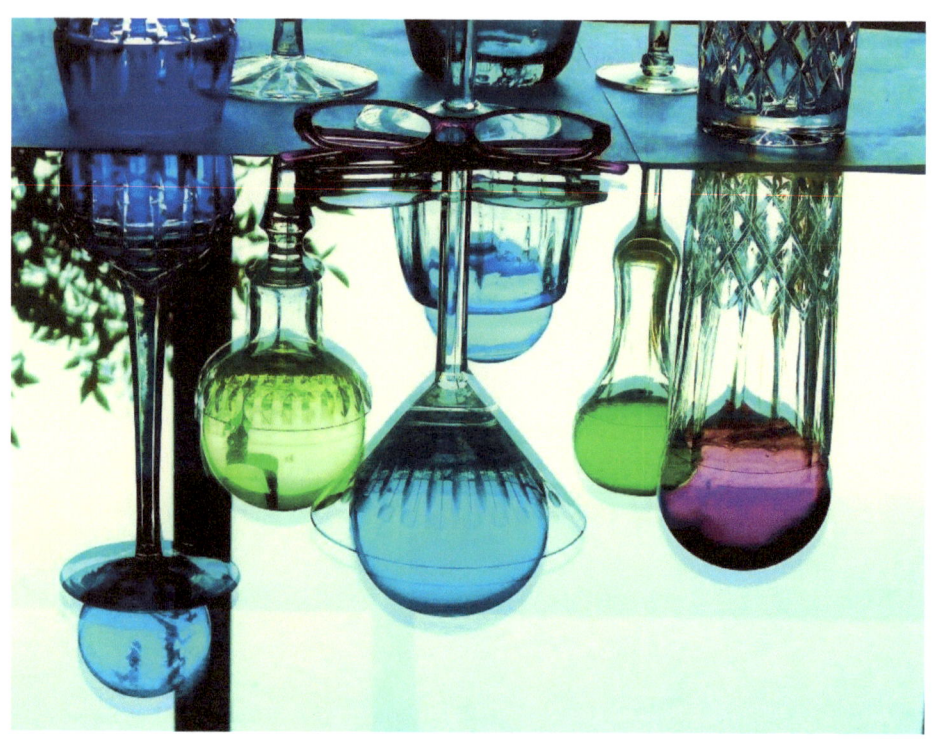

Glasses and Reflections.

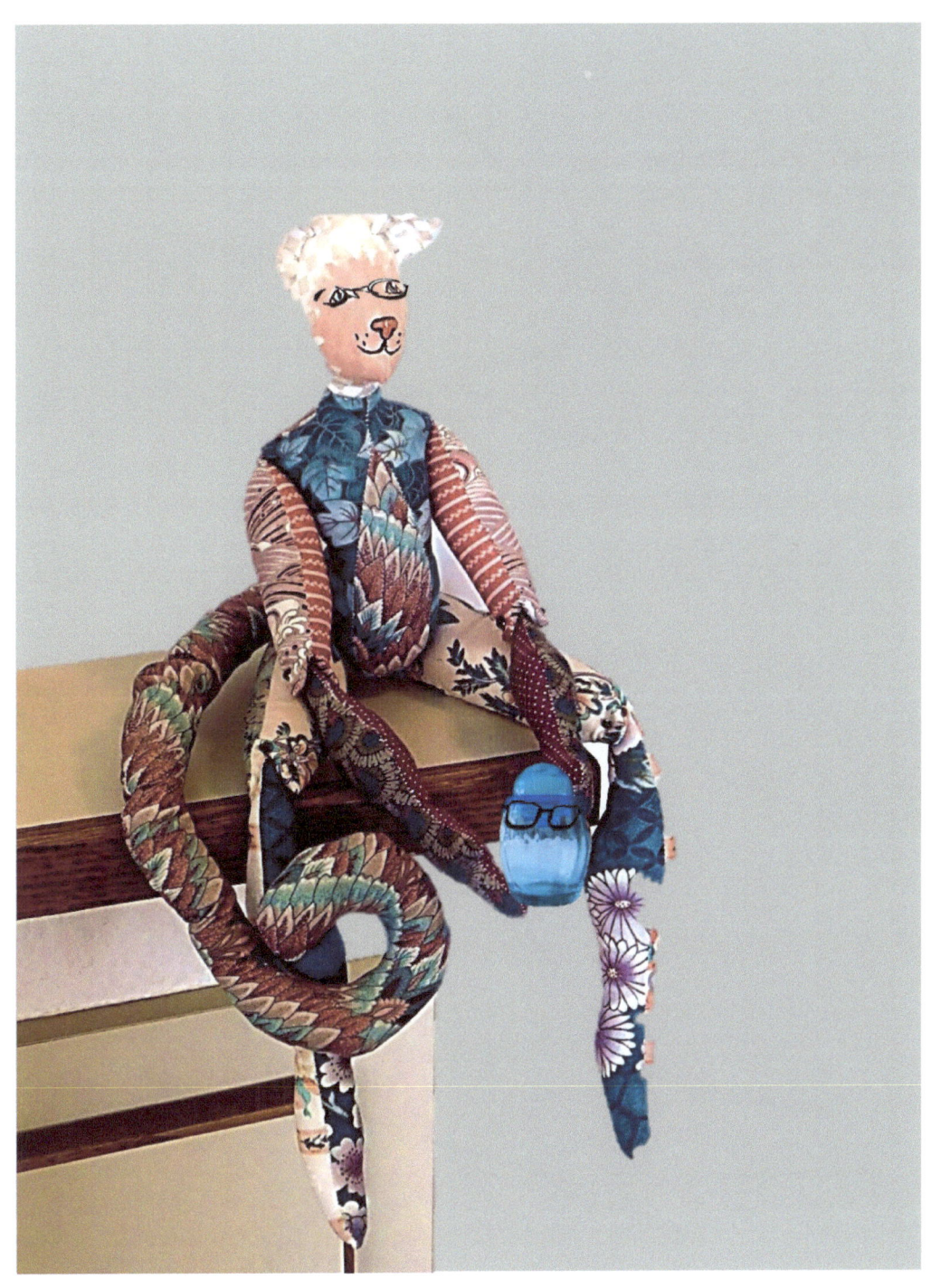

Thereby hangs a tail.

It looks mighty suspicious to me!

Don't be silly, dear.

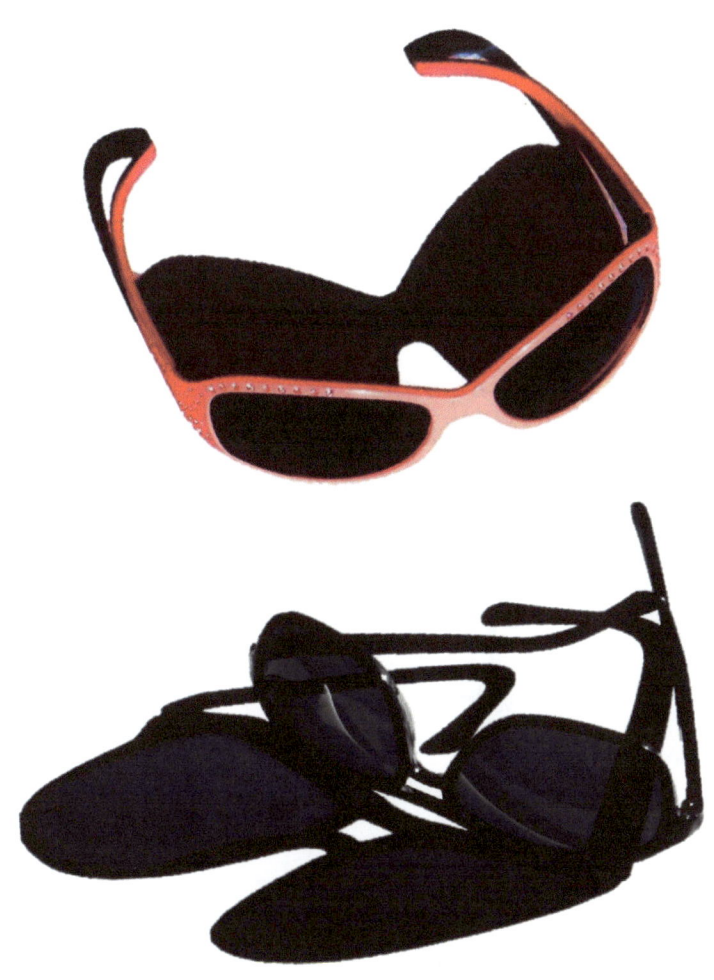

Glasses, the dark side.

Glasses on --

parade.--

Sweet Peas

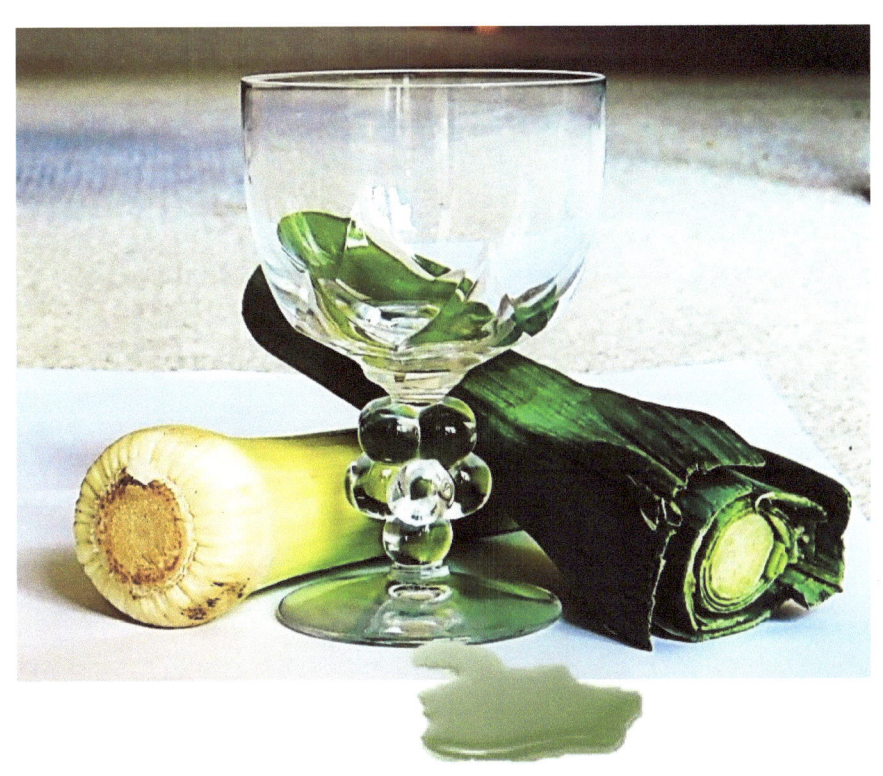

Lalique

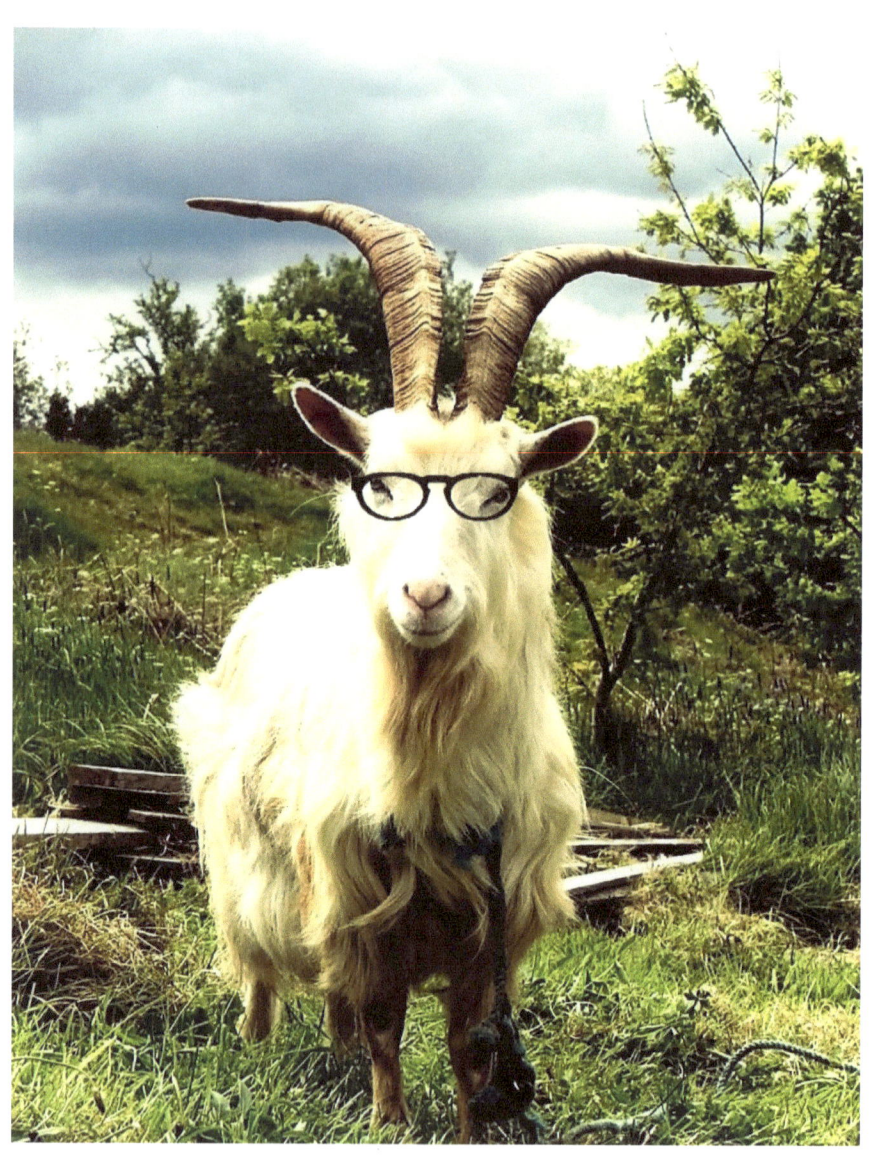

Put glasses on a goat and it is still a goat.

Old Irish saying (almost)

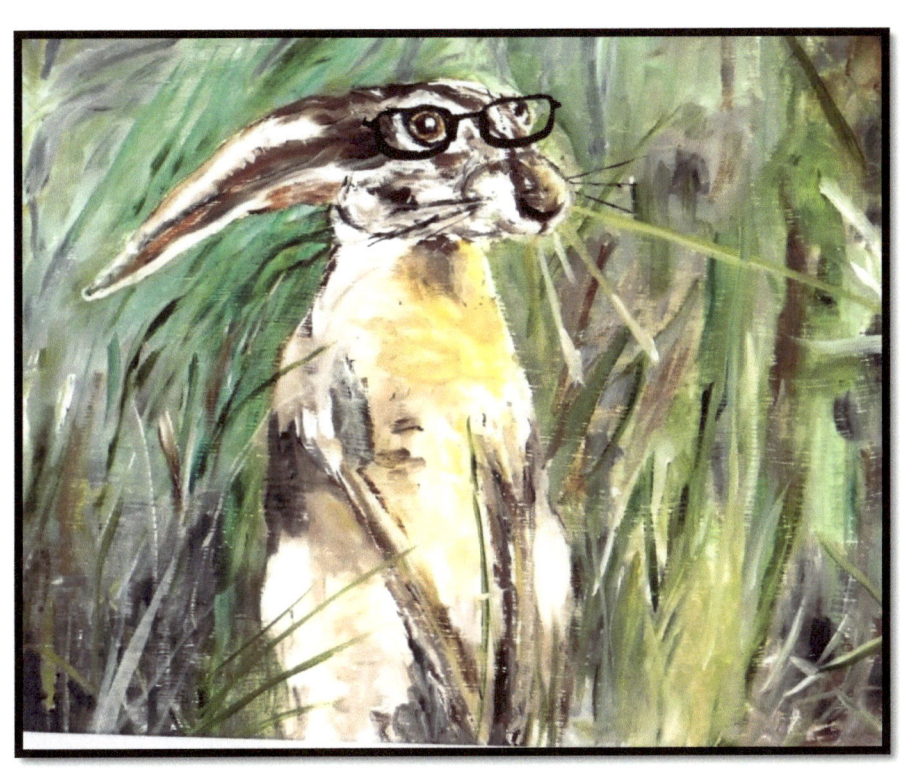

--or a Rabbit.

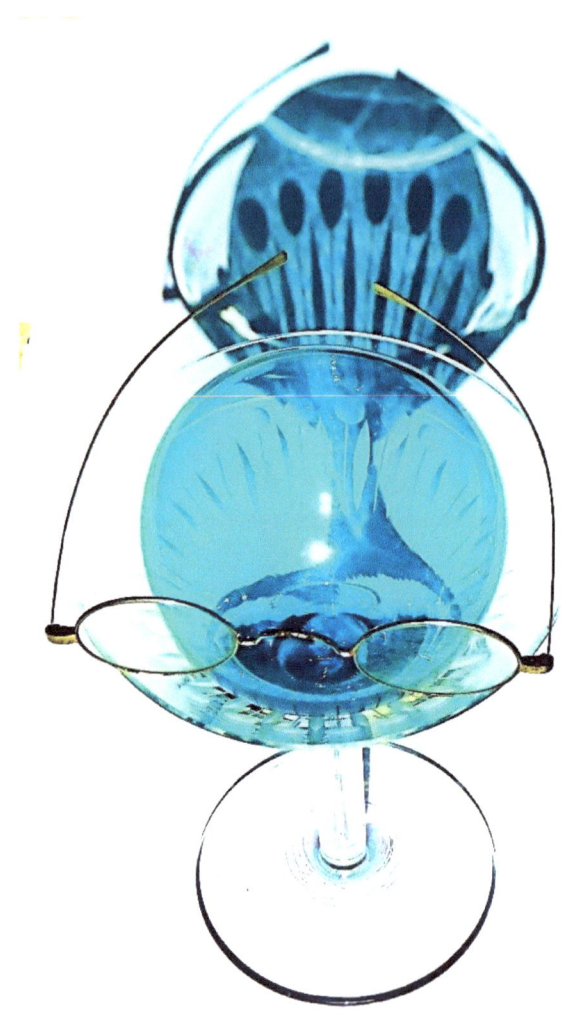

Glasses & Glasses ---

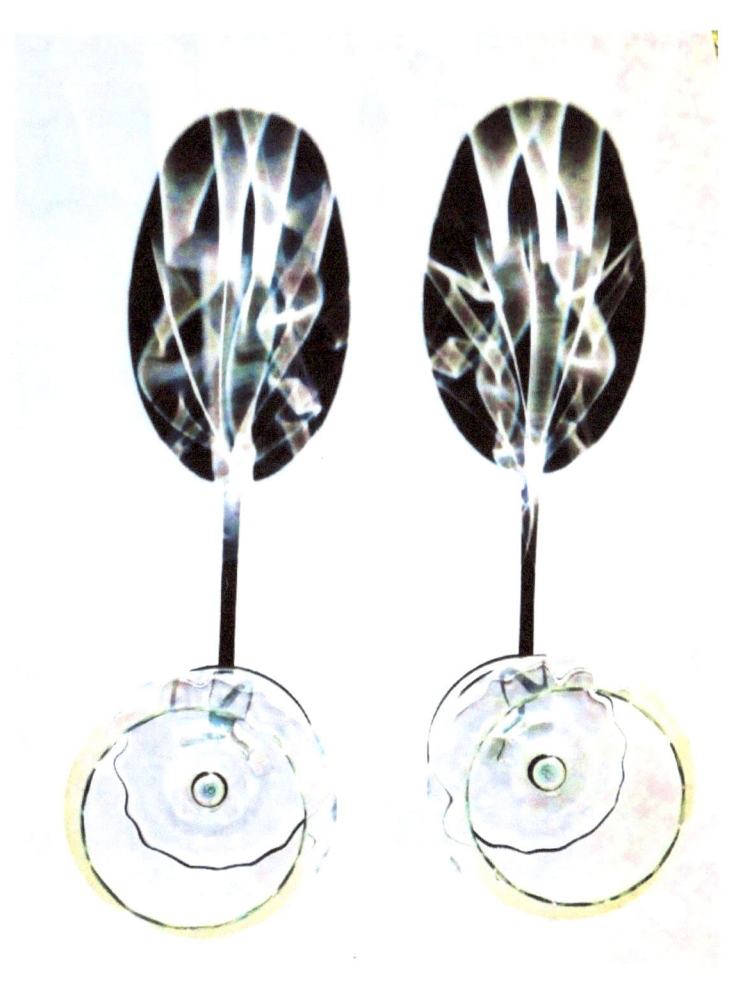

& Shadows

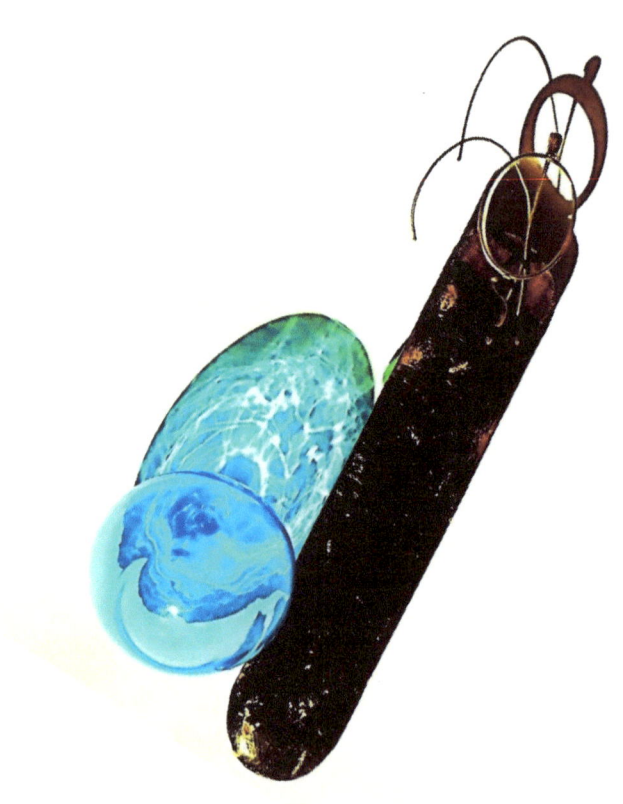

Just in case.

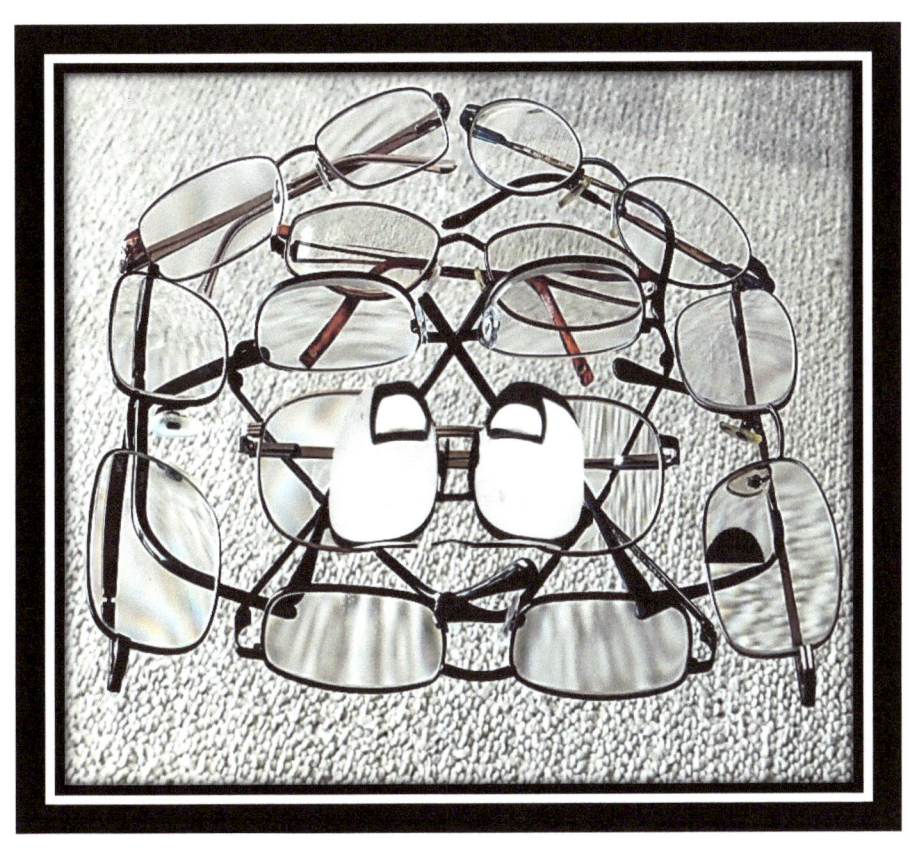

People who live in glasses houses ----

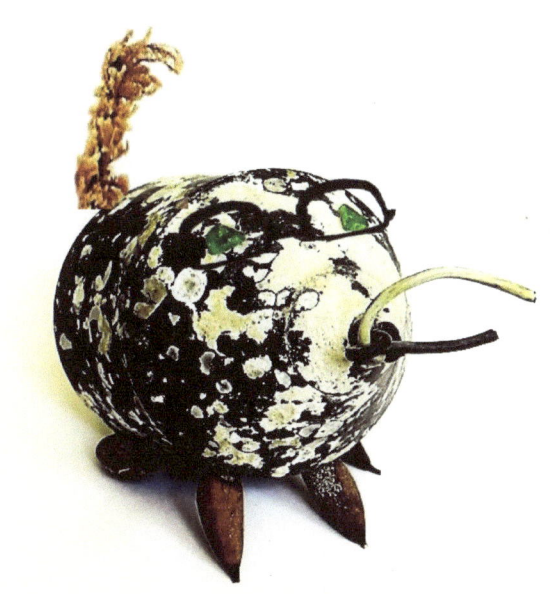

The End

www.ingramcontent.com/pod-product-compliance
Lightning Source LLC
Chambersburg PA
CBHW041110180526
45172CB00001B/196